T D Z

N L S

M A H

J U B

Y I E

C K N

B V R

G Q E

I K O

S C X

D N L

P W F

Tigers and Sails and ABC Tales

This book is made possible by The Mellon Endowment Fund.

Library of Congress Cataloging-in-Publication Data available

ISBN 0-917046-65-X

Printed in Spain

Distributed by John F. Blair, Publisher

Produced by the Office of Publications, Virginia Museum of Fine Arts, 2800 Grove Avenue, Richmond, Virginia 23221-2466 USA

Photographs for letters D, E, G, P, R, S, X, and Z by Museum staff.
Photographs for all other letters by Katherine Wetzel.
Edited by Anne Adkins
Book Design by Jean Kane
Project Managed by Sara Johnson-Ward
Composed by the designer in Quark Xpress
Typeset in New Century Schoolbook and Univers
Printed on 100-lb. Gardamatte Demi Matte text

Special thanks to Susan K. Bishop, Vice President and Director of Rainbow Station; Gina Dizon, Preschool Assistant Director of Rainbow Station; and all other Rainbow Station staff and children who participated in the development of this book. Additional thanks are extended to Betty Garrett and the Grace and Holy Trinity Child Care Center staff and children for their generosity; to Della Watkins for her gracious assistance; and to Jacky Robinson and Mary Jo Kearfott for their guidance.

Tigers and Sails and ABC Tales

Malcolm Cormack
Virginia Museum of Fine Arts
Richmond, Virginia

Aa

A is for artist

who draws with such care

A B C D E F G H I J K L M N O P Q R S T U V W X Y Z

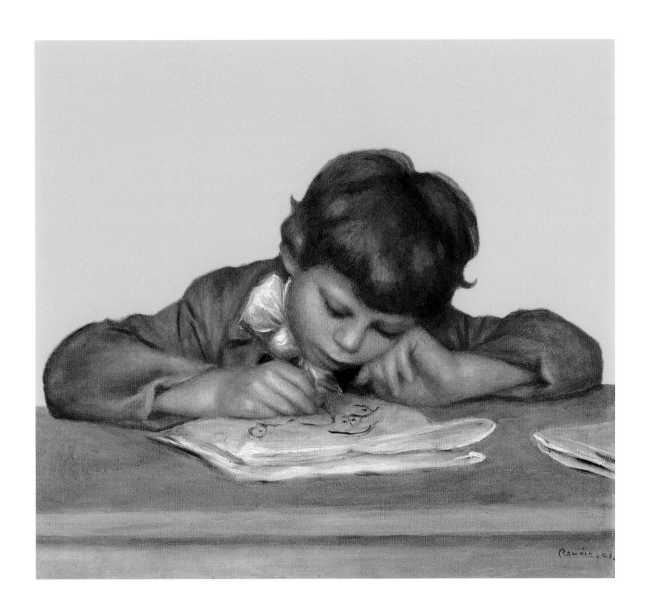

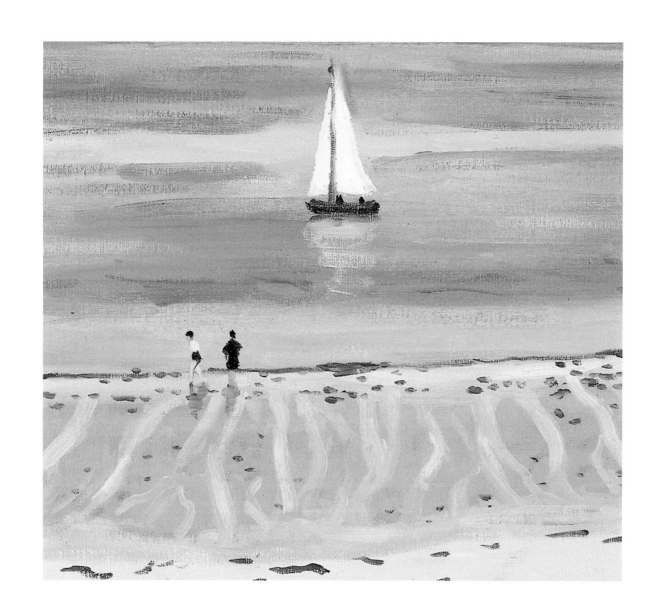

Bb

B is for beach

where children have fun

Cc

c is for cows

standing by the barn

A B C D E F G H I J K L M N O P Q R S T U V W X Y Z

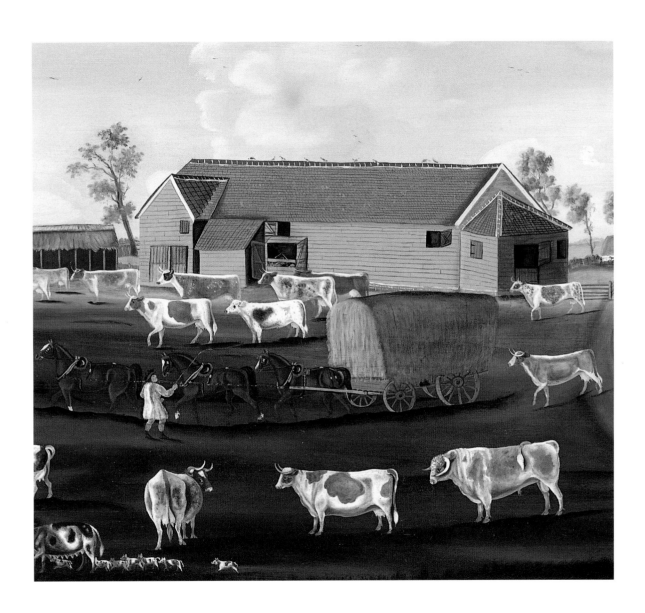

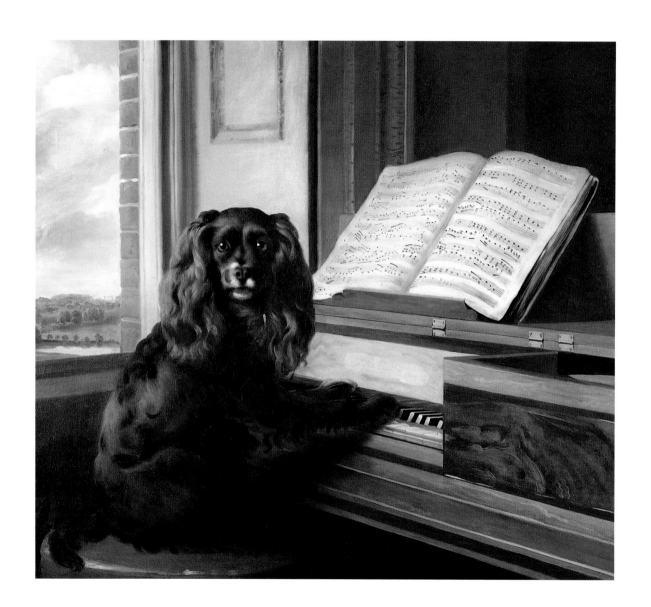

Dd

D is for dog

who plays music all day

A B C **D** E F G H I J K L M N O P Q R S T U V W X Y Z

Ee

E is for earring

gleaming all bright

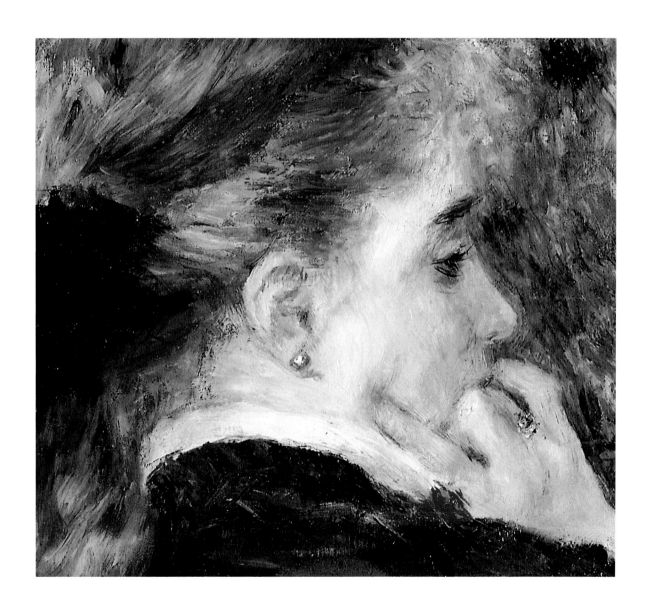

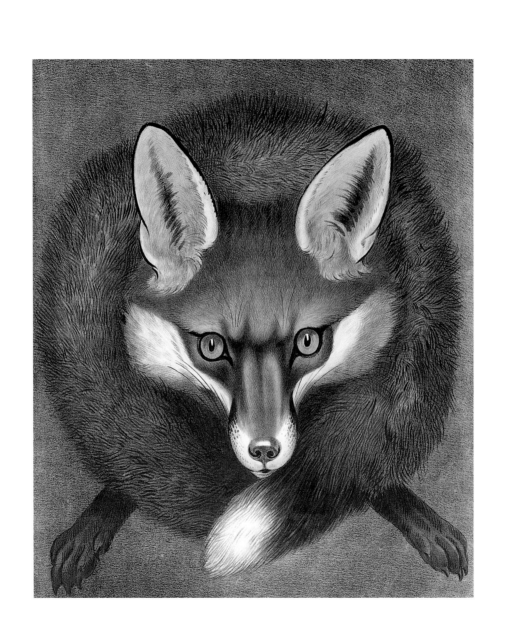

F is for fox

with his tight tangled tail

A B C D E **F** G H I J K L M N O P Q R S T U V W X Y Z

Gg

G is for green

of the grass all around

A B C D E F **G** H I J K L M N O P Q R S T U V W X Y Z

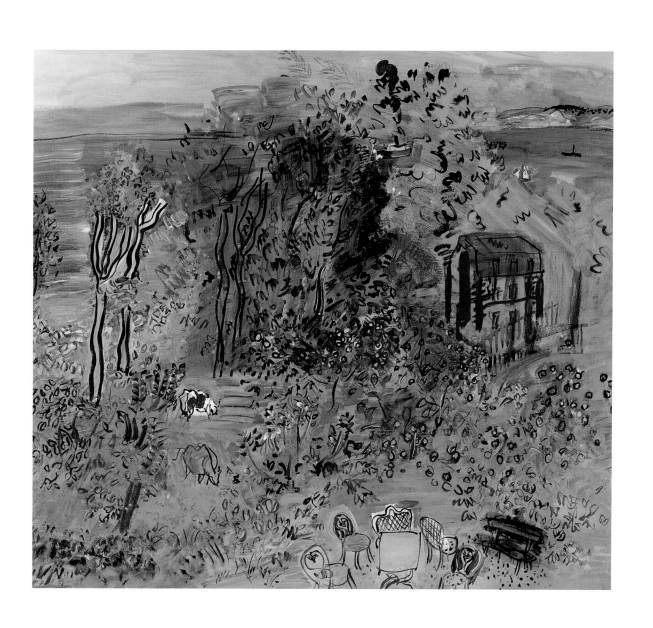

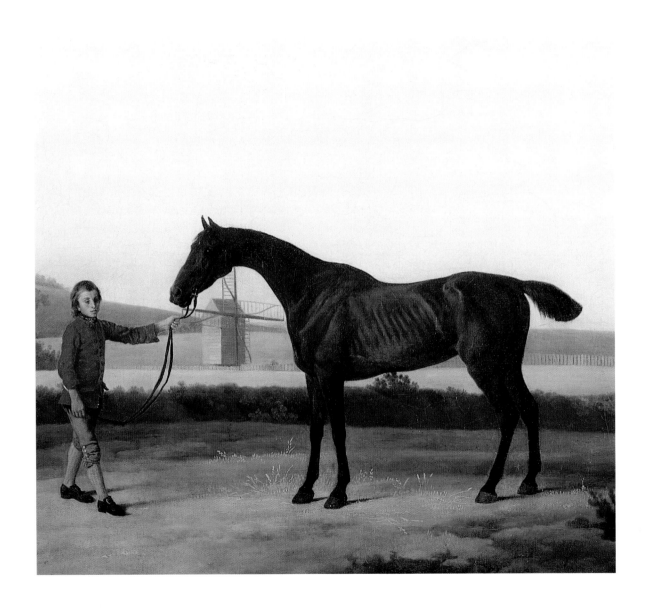

Hh

H is for horse

held close by the boy

A B C D E F G **H** I J K L M N O P Q R S T U V W X Y Z

Ii

I is for island

where the palm trees gr**OW**

A B C D E F G H I J K L M N O P Q R S T U V W X Y Z

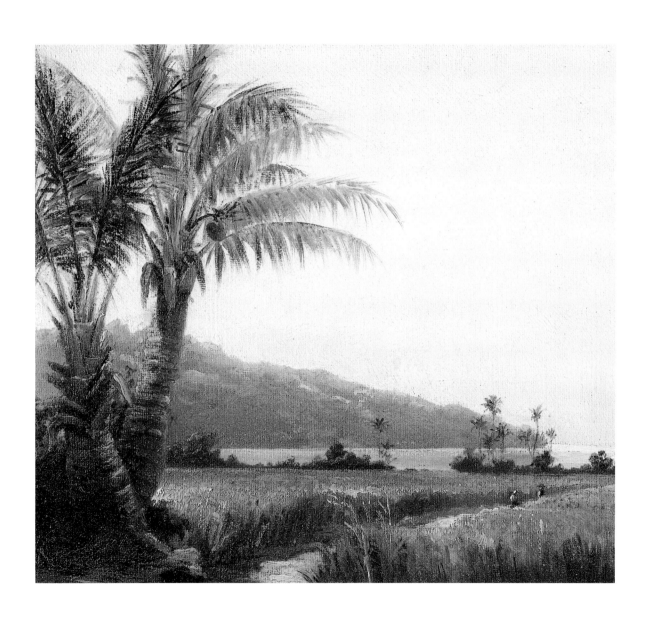

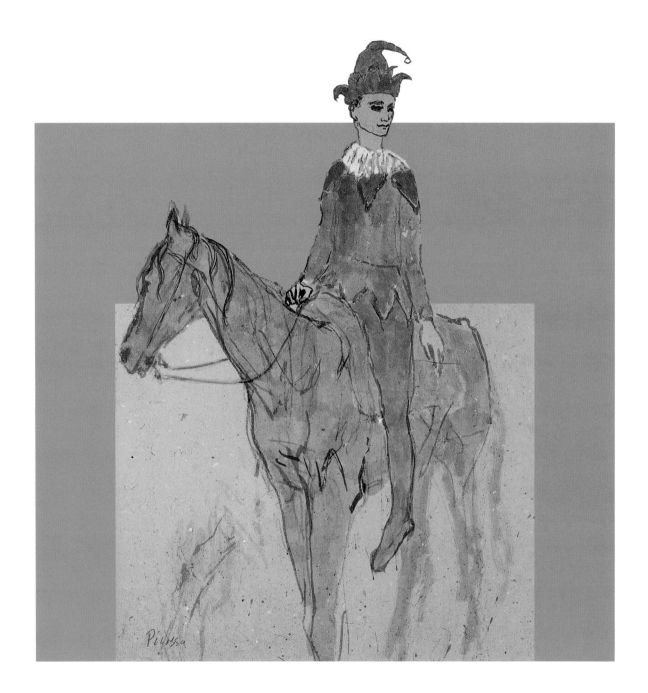

Jj

J is for jester

who rides on a horse

ABCDEFGHI**J**KLMNOPQRSTUVWXYZ

Kk

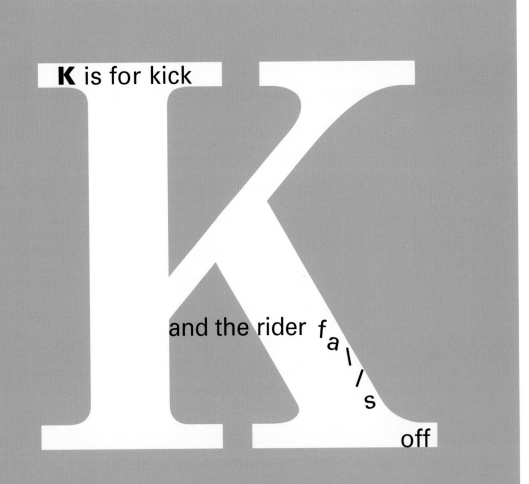

K is for kick

and the rider f*a*l l *s* off

ABCDEFGHIJKLMNOPQRSTUVWXYZ

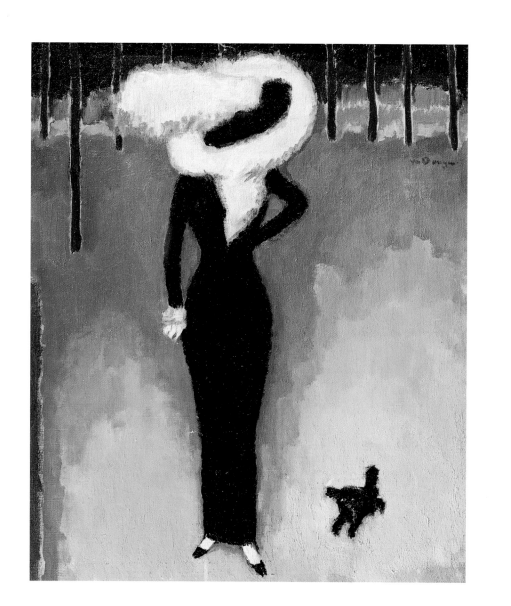

Ll

L is for lady

who wears a **BIG** hat

A B C D E F G H I J K **L** M N O P Q R S T U V W X Y Z

Mm

M is for man

who has a gray beard

A B C D E F G H I J K L **M** N O P Q R S T U V W X Y Z

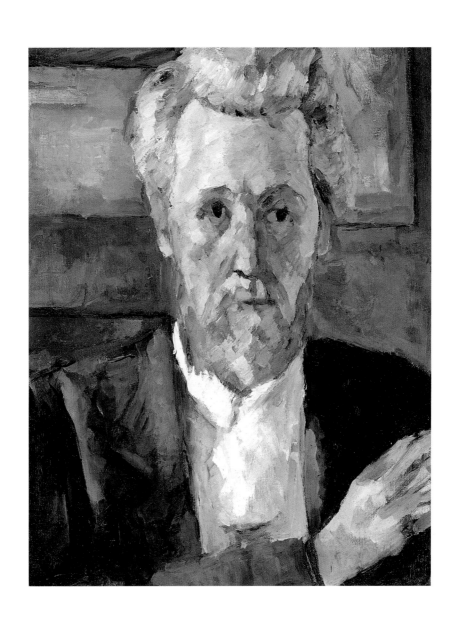

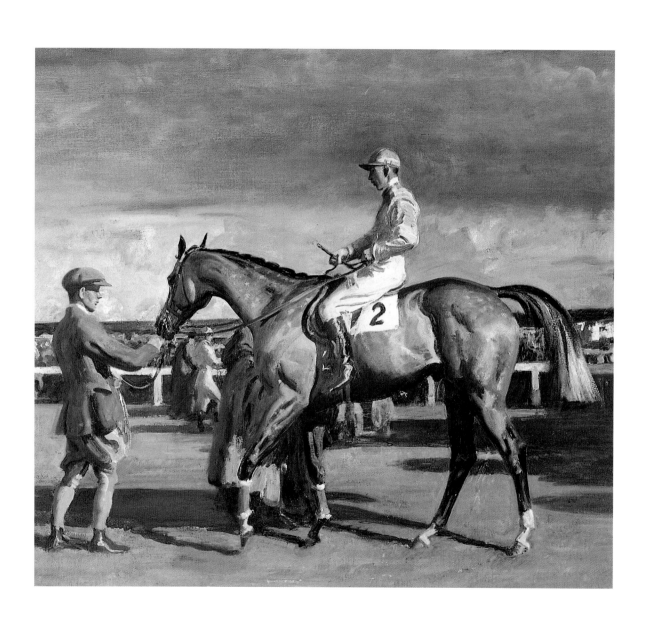

N is for number

on horse number two

A B C D E F G H I J K L M N O P Q R S T U V W X Y Z

Oo

O

o is for oxen

that have grown so large

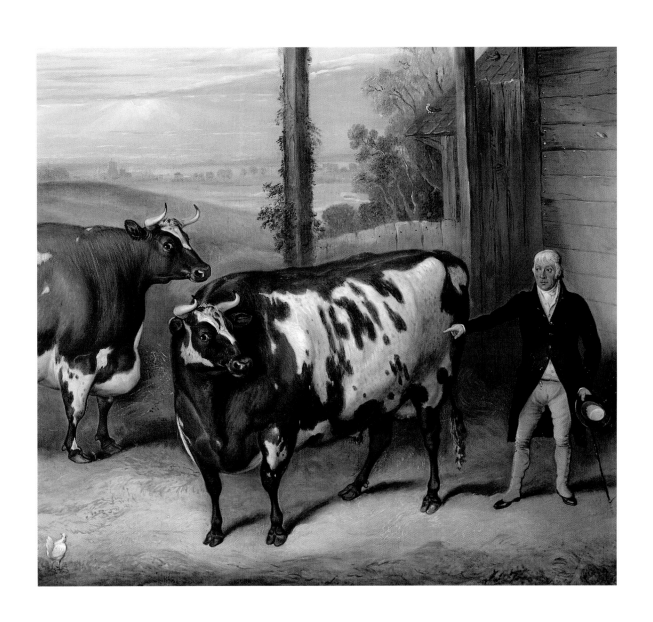

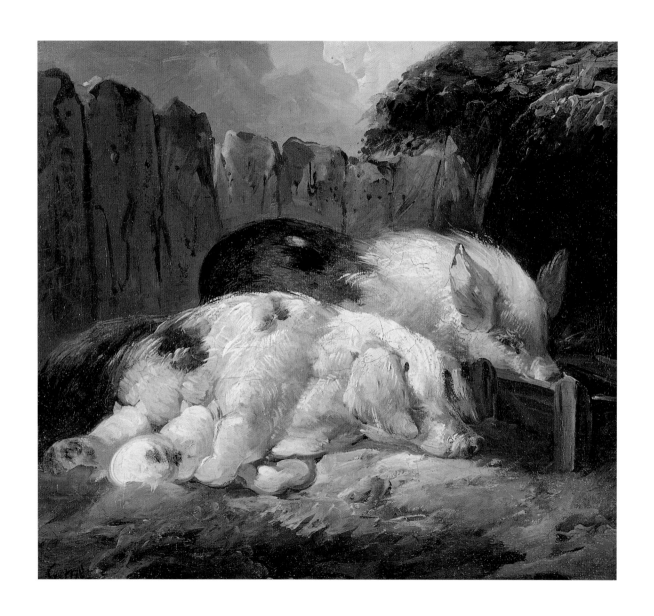

Pp

P is for piglets

so snug in the sty

Qq

Q is for quick

as the hare runs a w a y

A B C D E F G H I J K L M N O P Q R S T U V W X Y Z

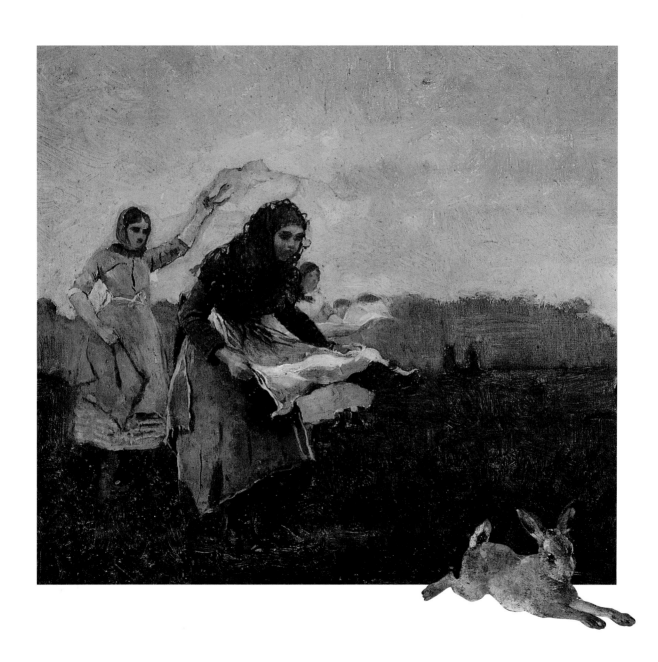

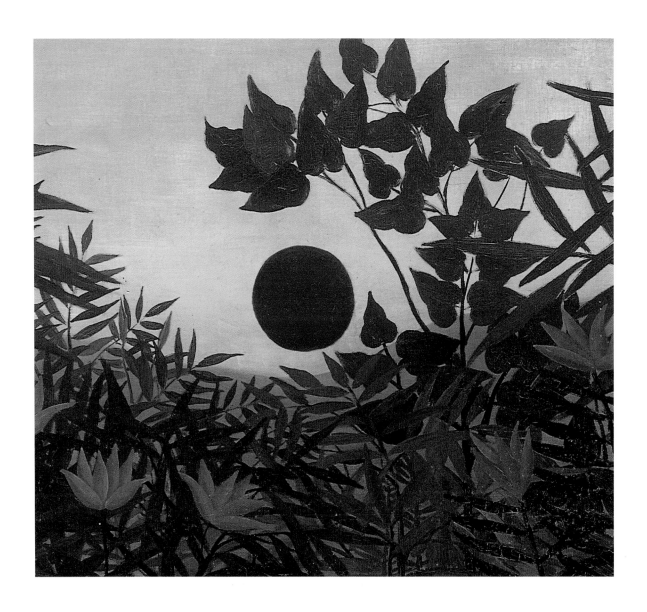

Rr

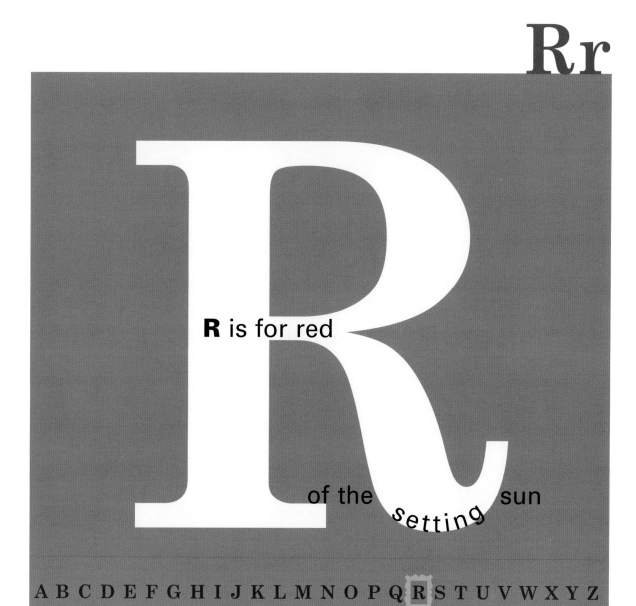

R is for red

of the setting sun

ABCDEFGHIJKLMNOPQRSTUVWXYZ

Ss

s is for sled

slidi n g

fast down the slope

A B C D E F G H I J K L M N O P Q R **S** T U V W X Y Z

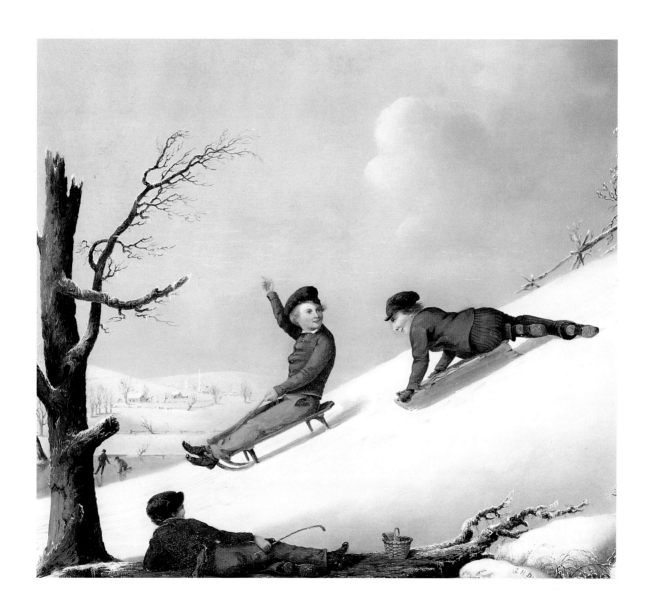

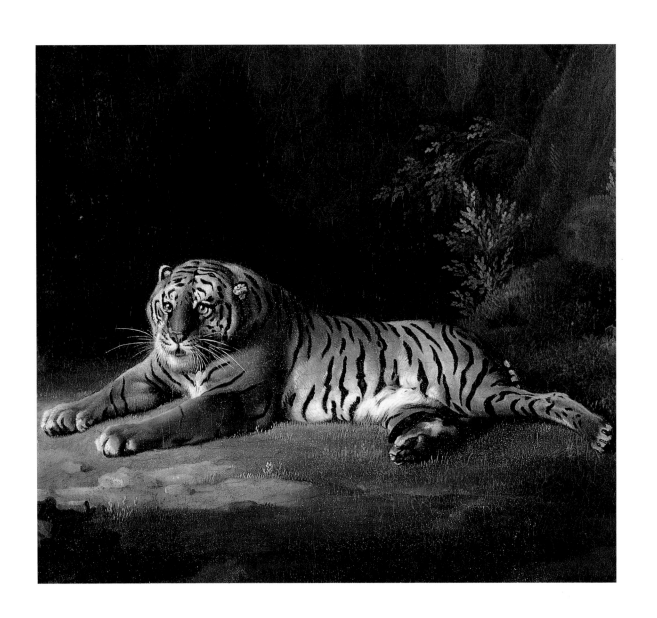

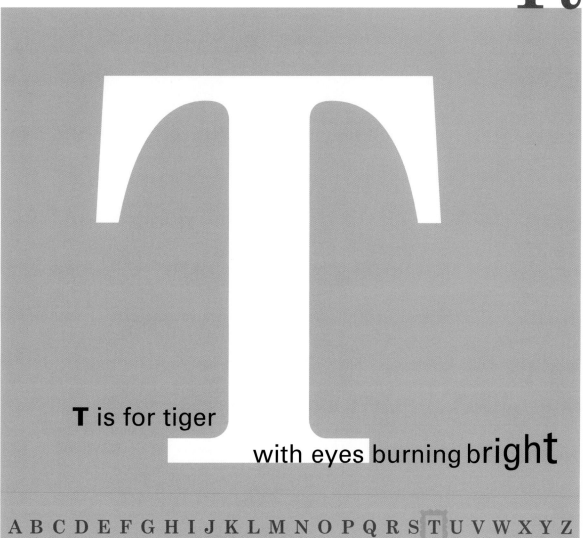

T is for tiger

with eyes burning br**ight**

A B C D E F G H I J K L M N O P Q R S T U V W X Y Z

Uu

U is for umbrella

held ^{up} to the sky

A B C D E F G H I J K L M N O P Q R S T U V W X Y Z

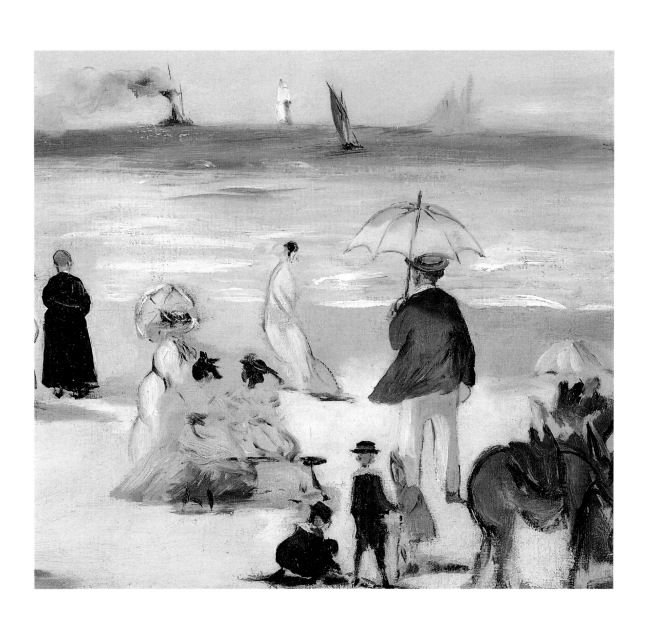

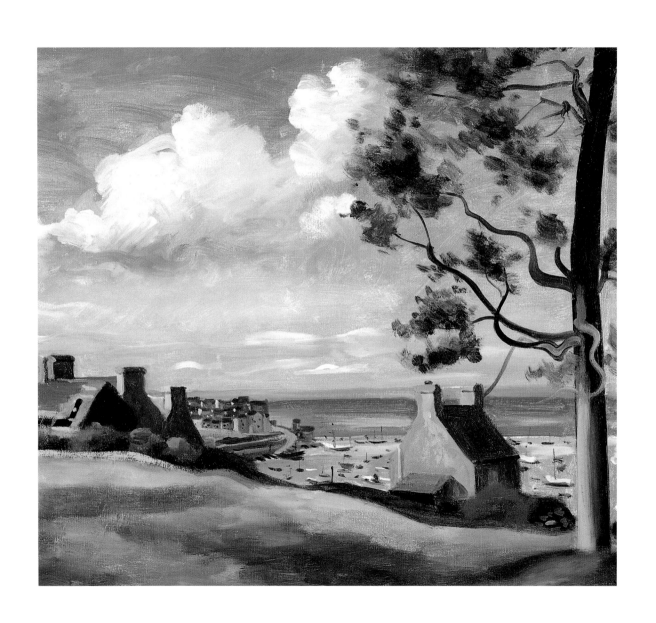

V

V is for village

set by the blue sea

ABCDEFGHIJKLMNOPQRSTUVWXYZ

Ww

W is for window

with the curtains tied back

ABCDEFGHIJKLMNOPQRSTUVWXYZ

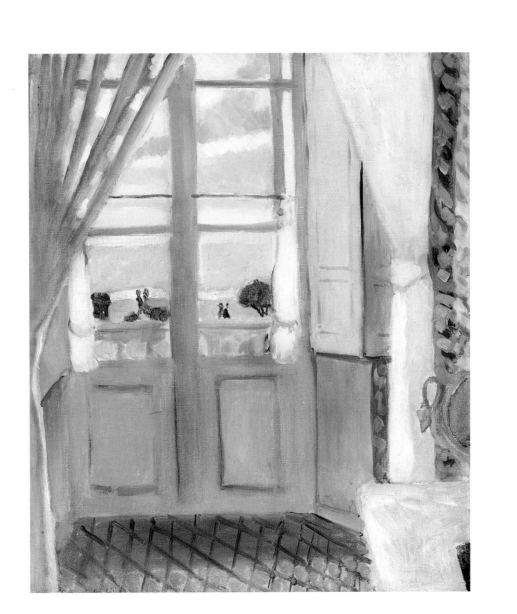

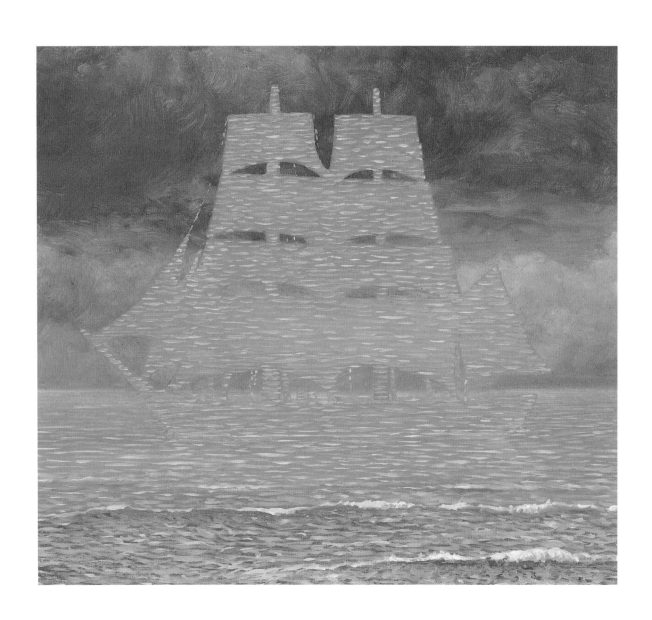

X is for x ray

that sees through the sails

A B C D E F G H I J K L M N O P Q R S T U V W X Y Z

Yy

Y is for yellow

of the dog's warm coat

A B C D E F G H I J K L M N O P Q R S T U V W X Y Z

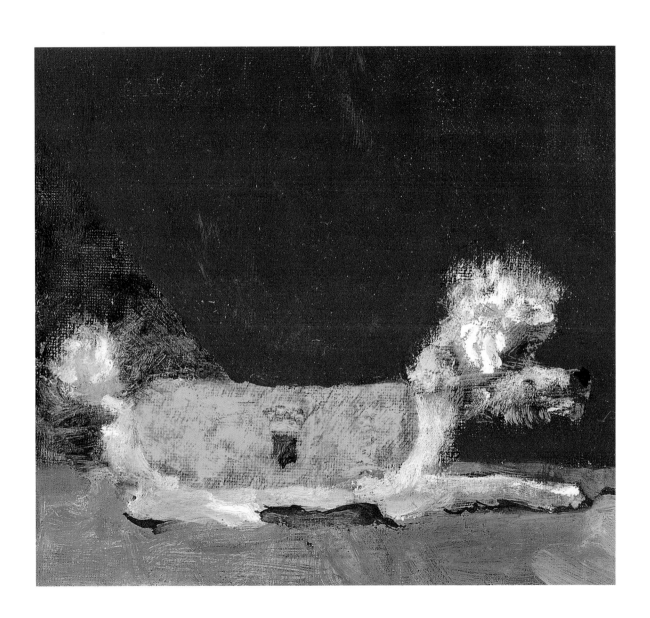

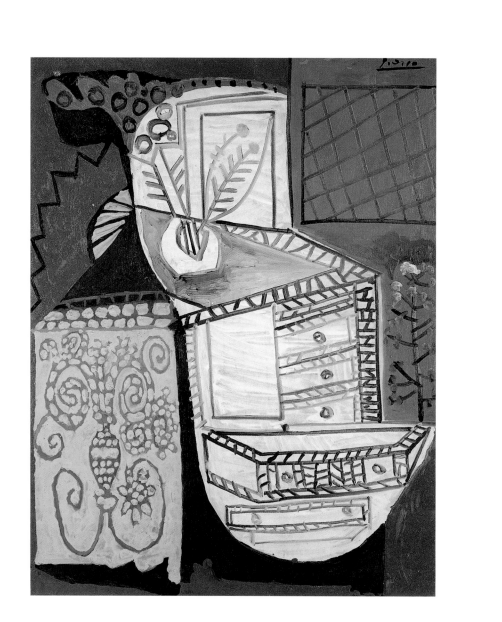

Zz

Z is for zig zag

of the black painted lines

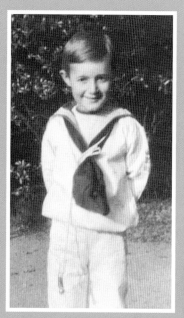

Paul Mellon in 1913, age six

Without the generosity of Paul Mellon, the Virginia Museum of Fine Arts would not be what it is today. Mr. Mellon donated more than 2,000 works of art to the Museum and the citizens of Virginia, including the 26 works featured in this book. These cherished treasures reside at the Virginia Museum of Fine Arts for all to enjoy. We hope you take pleasure in sharing these pages with a child.

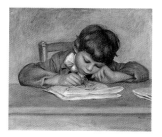

 A

The Artist's Son, Jean, Drawing, 1901
Pierre-Auguste Renoir
(French, 1841–1919)
Oil on canvas
17 3/4 by 21 1/2 inches
Collection of Mr. and Mrs. Paul Mellon, 83.48

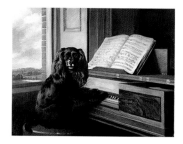

 D

Portrait of an Extraordinary Musical Dog, 1805
Philip Reinagle, R.A.
(English, 1749–1833)
Oil on canvas
28 1/4 by 36 1/2 inches
The Paul Mellon Collection, 85.465

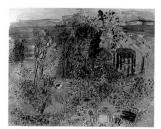

 G

View of Villerville, 1930
Raoul Dufy
(French, 1877–1953)
Oil on canvas
28 7/8 by 36 1/4 inches
Collection of Mr. and Mrs. Paul Mellon, 94.63

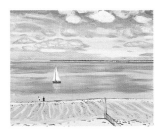

Ebb Tide at Pyla, 1935
Albert Marquet
(French, 1875–1947)

Oil on canvas
25 1/2 by 31 3/4 inches
Collection of Mr. and Mrs.
Paul Mellon, 85.502

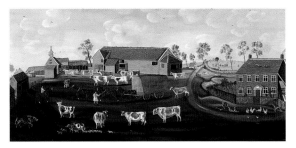

Farm Scene in Summer, 1802
William Williams
(English?, active 1802)

Oil on panel
28 7/8 by 59 1/8 inches
The Paul Mellon Collection, 85.479.1

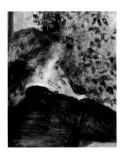

Pensive, 1875
Pierre-Auguste Renoir
(French, 1841–1919)

Oil on paper on canvas
18 1/8 by 15 inches
Collection of Mr. and Mrs. Paul Mellon,
83.47

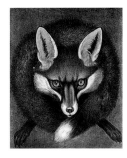

Title Page for "The Beaufort Hunt," 1833
Walter Parry Hodges
(English, 1760–1845)

Lithograph
Title page 30 by 22 1/8 inches
The Paul Mellon Collection, 85.1446.1/9

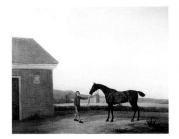

*Hyena with a Groom
on Newmarket Heath,*
ca. 1767
George Stubbs
(English, 1724–1806)

Oil on canvas
40 1/8 by 50 1/8 inches
The Paul Mellon Collection,
99.93

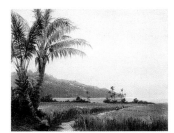

*Coconut Palms by the Sea,
St. Thomas,* 1856
Camille Pissarro
(French, 1830–1903)

Oil on canvas
10 1/2 by 13 3/4 inches
Collection of
Mr. and Mrs. Paul Mellon, 83.45

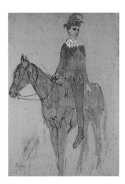

Jester on Horseback, 1905
Pablo Picasso
(Spanish, 1881–1973)

Oil on composition board
39 3/8 by 27 1/4 inches
Collection of Mr. and Mrs. Paul Mellon, 84.2

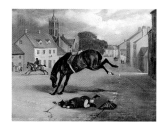

Count Sandor's Hunting Exploits in Leicestershire, No. 1: Represents the Count floored in the streets of Melton Mowbray. He was . . . putting on his gloves, when his horse Cruiser, started at a drain, and sitting loosely at the time, he kissed Mother Earth, 1829
John E. Ferneley, Sr.
(English, 1782–1860)

Oil on canvas
10 7/8 by 14 1/8 inches
The Paul Mellon Collection, 99.63

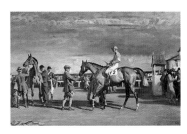

After the Race, Cheltenham, Saddling Paddock, ca. 1946
Sir Alfred J. Munnings, P.R.A.
(English, 1878–1959)

Oil on canvas
40 3/4 by 63 3/4 inches
The Paul Mellon Collection, 99.84

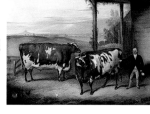

Two Durham Oxen, 1827
Thomas Weaver
(English, 1774 or 1775–1843)

Oil on canvas
39 by 49 inches
The Paul Mellon Collection, 85.478

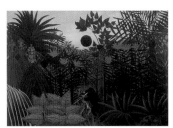

Tropical Landscape– An American Indian Struggling with a Gorilla, 1910
Henri Rousseau (La Douanier)
(French, 1844–1910)

Oil on canvas
44 3/4 by 64 inches
Collection of
Mr. and Mrs. Paul Mellon, 84.3

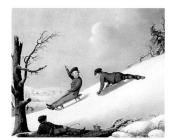

Sledding, 1851
George Henry Durrie
(American, 1820–1863)

Oil on panel
19 1/2 by 23 3/4 inches
The Paul Mellon Collection, 85.637

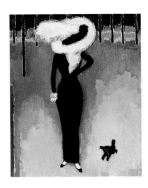

Parisian Lady, 1910
Kees Van Dongen
(Dutch, 1877–1968)

Oil on canvas
24 3/8 by 20 inches
Collection of
Mr. and Mrs. Paul Mellon, 83.21

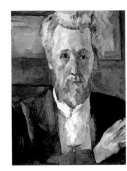

Victor Chocquet, ca. 1877
Paul Cézanne
(French, 1839–1906)

Oil on canvas
13 7/8 by 10 3/4 inches
Collection of Mr. and Mrs. Paul Mellon, 83.14

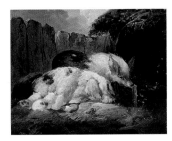

Pigs and Piglets in a Sty,
ca. 1800
George Morland
(English, 1763–1804)

Oil on canvas
9 1/2 by 12 inches
The Paul Mellon Collection,
85.472

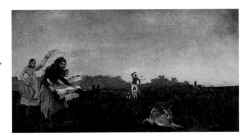

Coursing the Hare, ca. 1883
Winslow Homer
(American, 1836–1910)

Oil on canvas
14 7/8 by 27 1/2 inches
The Paul Mellon Collection, 85.642

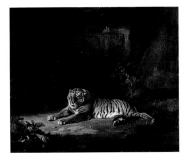

Tiger, ca. 1769–70
George Stubbs
(English, 1724–1806)

Oil on canvas
24 3/16 by 28 11/16 inches
The Paul Mellon
Collection, 99.95

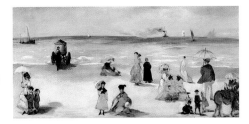

On the Beach, Boulogne-sur-Mer, 1868 or 1869
Edouard Manet
(French, 1832–1883)

Oil on canvas
12 5/8 by 25 5/8 inches
Collection of Mr. and Mrs. Paul Mellon, 85.498

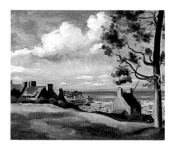

The Port of Douarnenez, 1936
André Derain
(French, 1880–1954)

Oil on canvas
20 by 23 ¾ inches
Collection of
Mr. and Mrs. Paul Mellon, 83.19

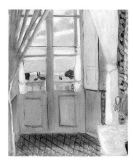

Interior, 1918–19
Henri Matisse
(French, 1869–1954)

Oil on canvas
21 ¼ by 17 ½ inches
Collection of Mr. and Mrs. Paul Mellon, 83.37

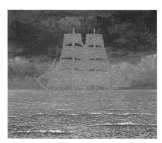

The Seducer, 1950
René Magritte
(Belgian, 1898–1967)

Oil on canvas
19 by 23 inches
Collection of
Mr. and Mrs. Paul Mellon, 83.34

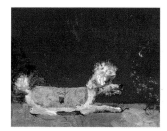

Fancy Dog, 1920
Kees Van Dongen
(Dutch, 1877–1968)

Oil on canvas
7 by 9 inches
Collection of Mr. and Mrs. Paul Mellon,
83.20

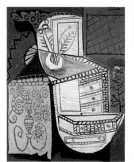

The Chinese Chest of Drawers, 1953
Pablo Picasso
(Spanish, 1881–1973)

Oil on panel
58 by 45 inches
Collection of Mr. and Mrs. Paul Mellon, 83.43

Front Cover Details:

Ebb Tide at Pyla, 1935
Albert Marquet

Tiger, ca. 1769–70
George Stubbs

T D Z

N L S

M A H

J U B

Y I E

C K N

B V R

G Q E

I K O

S C X

D N L

P W F